The Heart Takes Flight

anna elkins

wordbody

© 2012 Anna Elkins

w o r d b o d y
PO Box 509
Jacksonville, OR 97530
USA

All rights reserved. No part of this book may be reproduced in any form or by any means without permission in writing from the author.

ISBN-13: 978-0615604534

Cover design & all illustrations by Anna Elkins

For Dad, Mom, David,

and all those who've risked waking into their dreams.

With love,

Once, there lay
a restless
heart.

It dreamt of MORE

& slowly woke...

to find its feet,

to learn to
walk

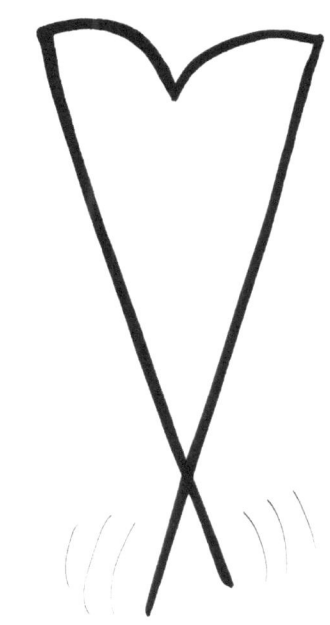

The heart walked
long & far.

It wanted MORE.

"I want to fly"

It shivered
&
shook

until it
broke.

"This isn't what I thought flight would feel like."

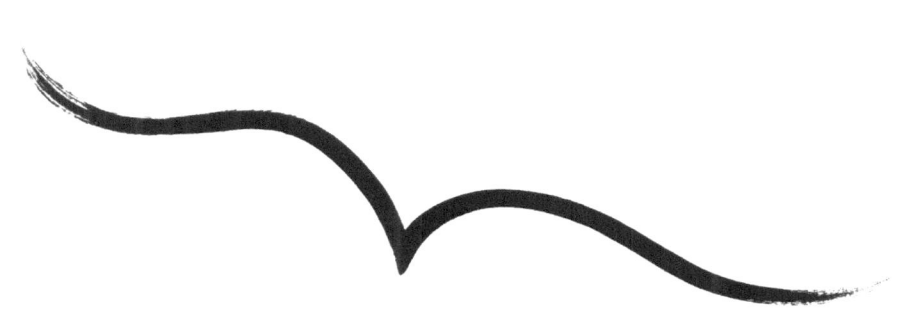

"Where am I?"

"Here you are,"
heard the heart.

"Where you've always been."

The heart rested
in those words,

& lived happily ever after..

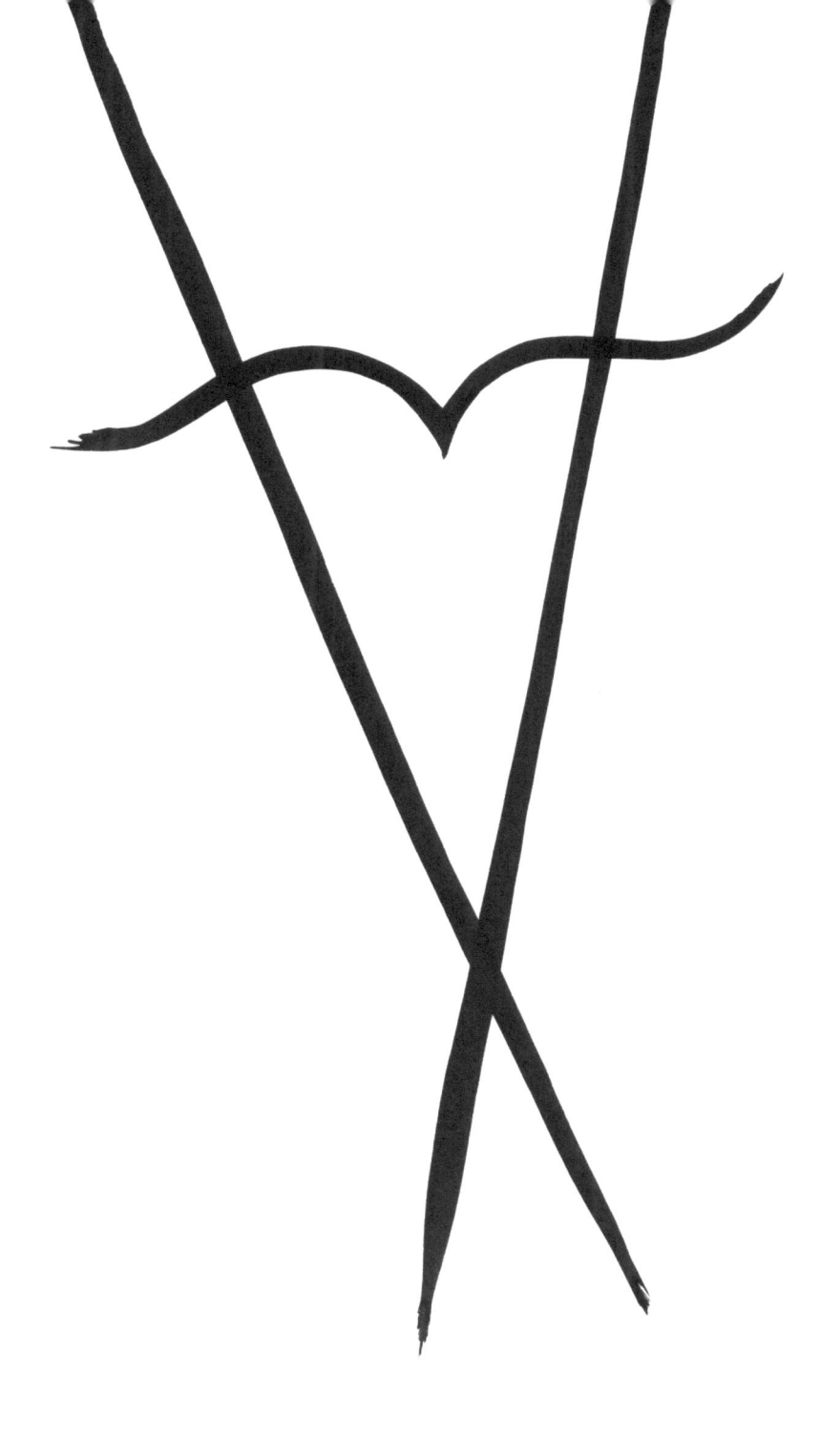

the beginning...

Send me the story of your heart flight:

annaelkins.com
ae@annaelkins.com

www.ingramcontent.com/pod-product-compliance
Lightning Source LLC
Chambersburg PA
CBHW051106180526
45172CB00002B/800